Isabella Rossellini
My Chickens and I

Isabella Rossellini
My Chickens and I

Photographs by
Patrice Casanova

Abrams Image, New York

I wanted chickens, so I ordered them online.
They arrived by mail in this box.

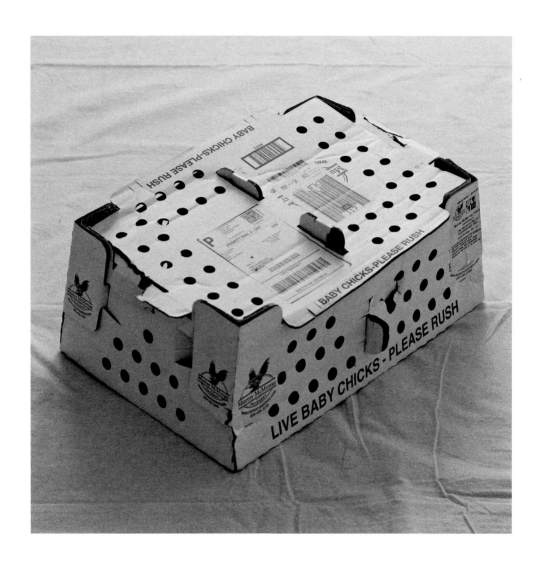

I expected all the chicks to look like this …

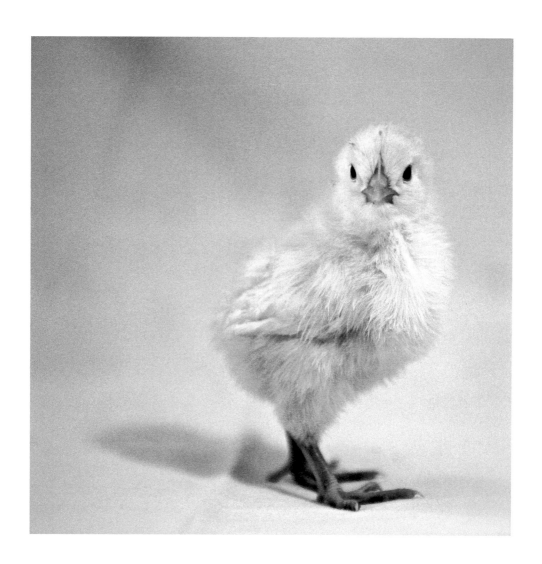

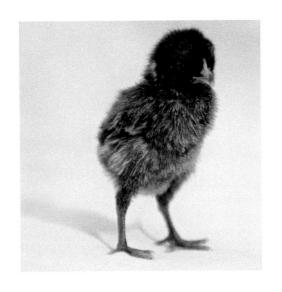

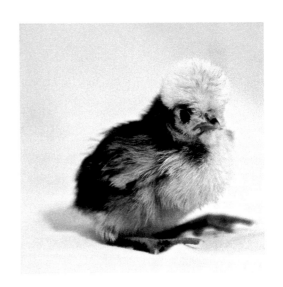

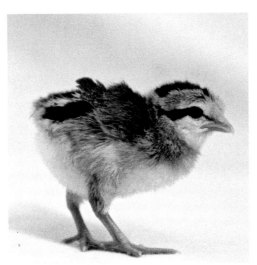

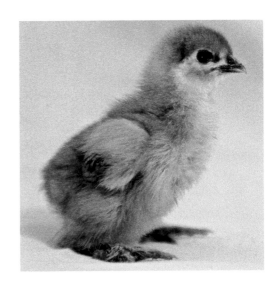

… but instead
they looked like this.

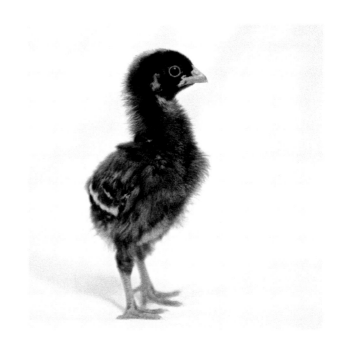

Some were
heritage breed chickens.

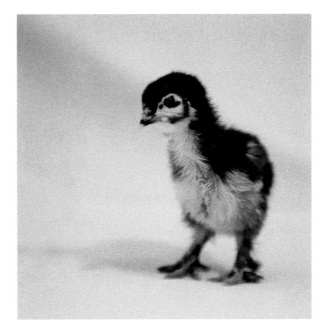

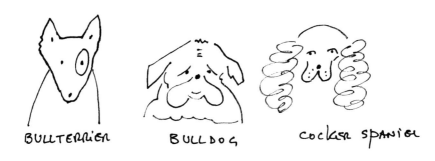

BULLTERRIER BULLDOG cocker spaniel

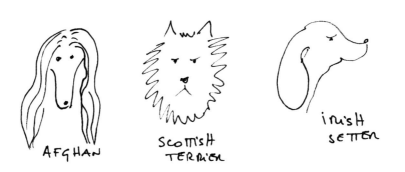

AFGHAN scottish terrier irish setter

Just as dogs have breeds …

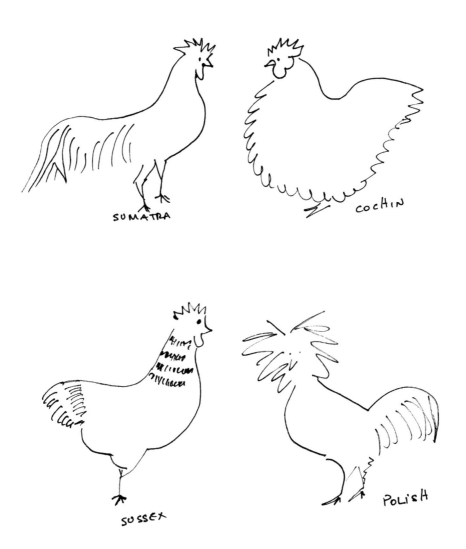

SUMATRA

COCHIN

SUSSEX

POLISH

… chickens have them, too.

1 week

2 months

1 week

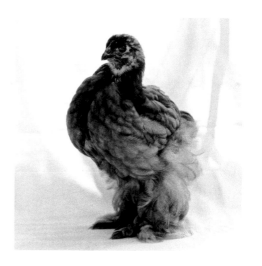

2 months

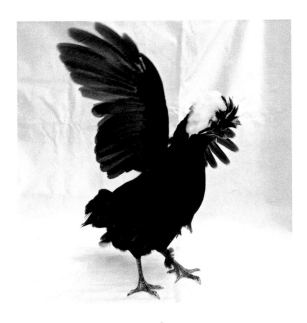

5 months

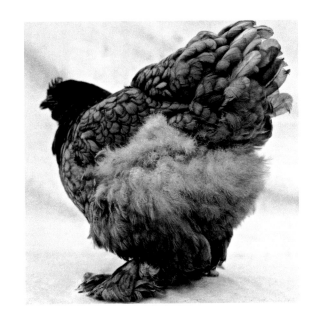

5 months

I asked my friend Patrice
to photograph the chickens
to capture their growth as they
become adults.

For chickens, adulthood begins
when they start laying eggs.

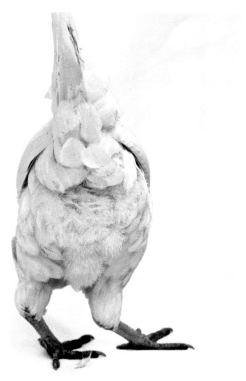

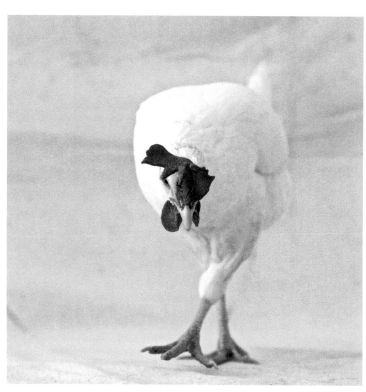

The photos revealed things
I couldn't see with my naked eye.
Chickens make many strange movements.

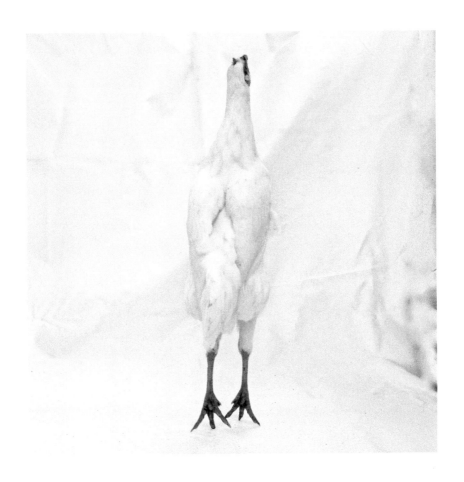

They have distinct personalities!

I didn't name all my chickens,
but a few have nicknames.
I call this chicken Andy Warhol,
after the artist, because of her hairdo.
She is the tamest of them all.
She is a crested Polish breed.

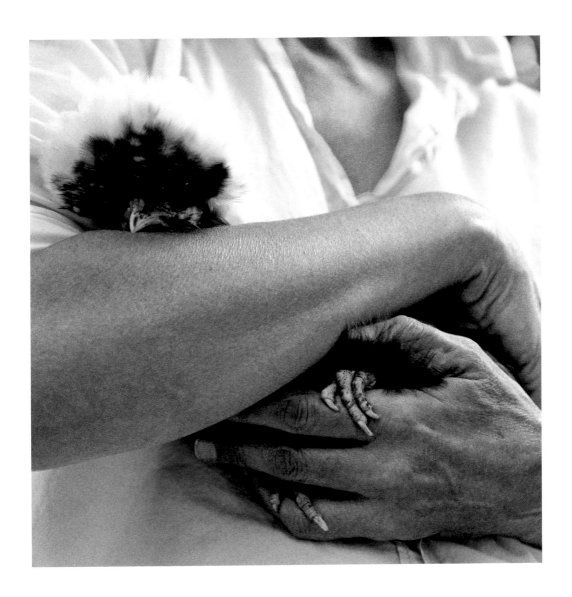

This one has two nicknames:
Red for the color of her feathers and
Amelia Earhart because she is fearlessly
adventurous, just like the aviator.

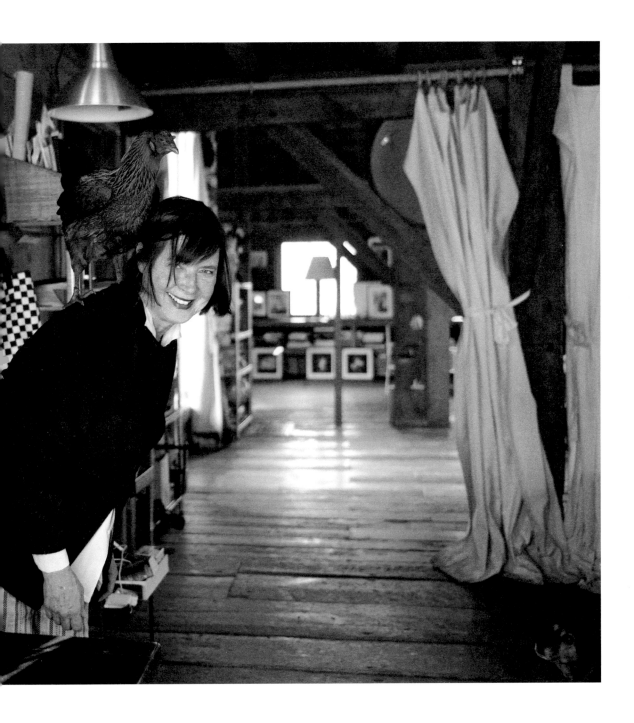

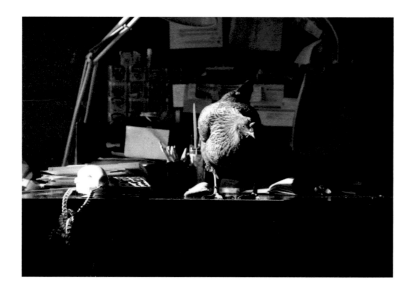

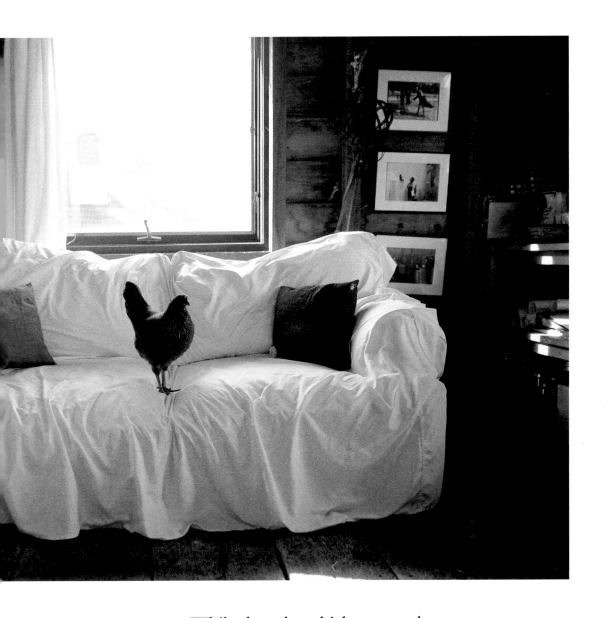

While the other chickens mostly
stay together, she wanders out on her own:
I've found her on my sofa and on my desk.
Her breed is Welsummer.

One I nicknamed Speedy.
She is flighty.
I was never able to catch her
and make her pose for Patrice
in our makeshift set.
I can only draw her
to show what she looks like.

Her breed is Modern Game.

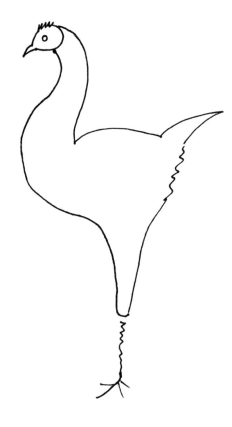

The set

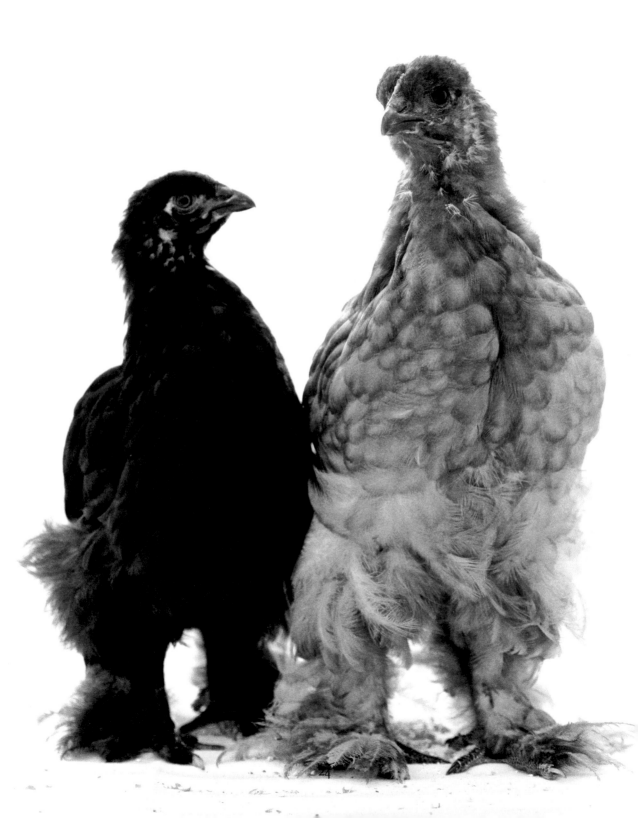

Chickens form friendships.

These two are always together.
Their breed is Cochin.

Friendships exist within the flock.
A flock is a chicken family, and they
don't like any intruders.

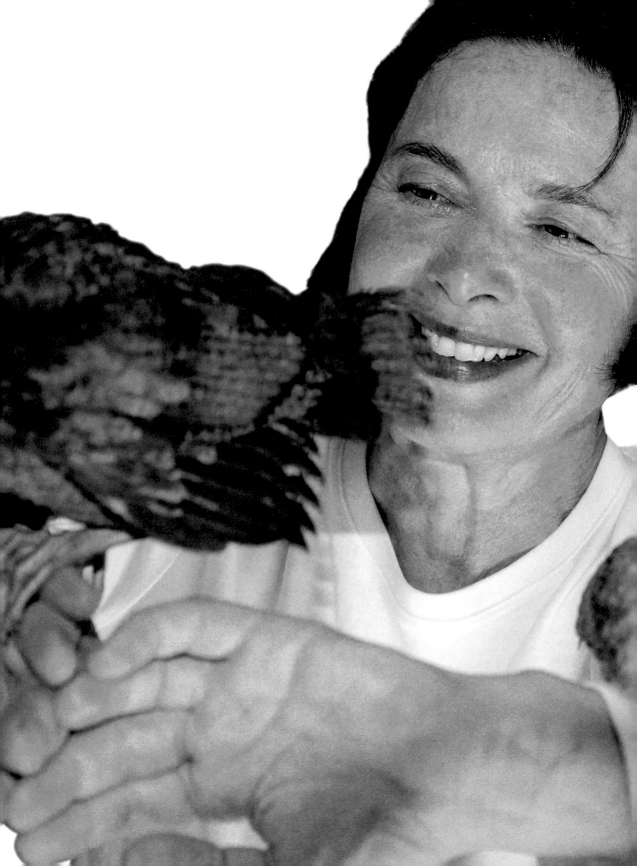

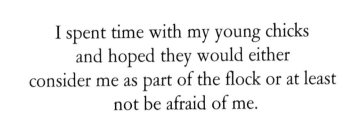

I spent time with my young chicks
and hoped they would either
consider me as part of the flock or at least
not be afraid of me.

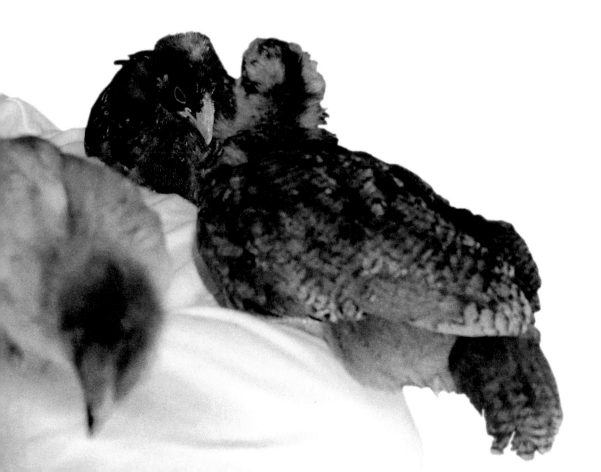

I like to caress chickens.
They are much softer than any cat or dog.

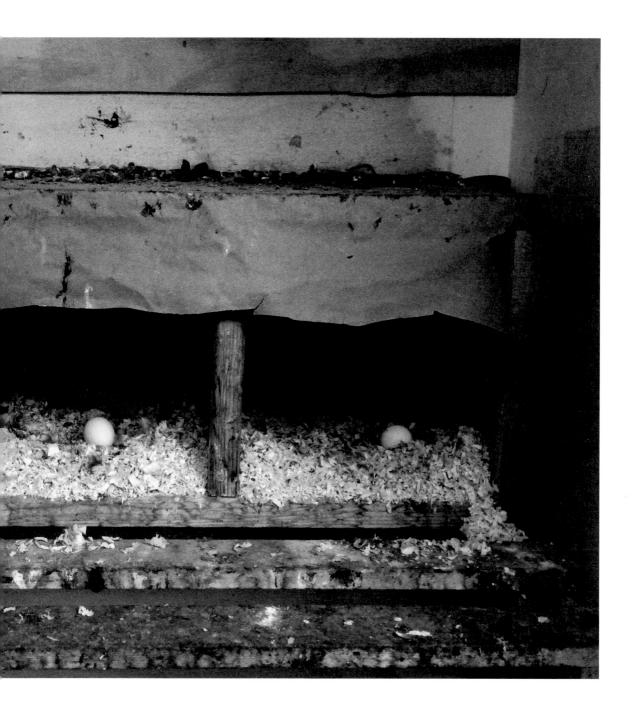

That is when Patrice and I stopped photographing them.

Now we just eat their eggs.

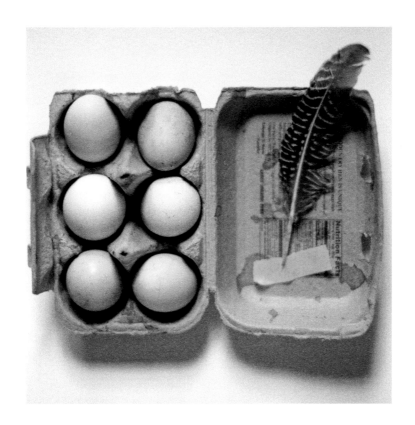

Notice the variation and diversity of my eggs …

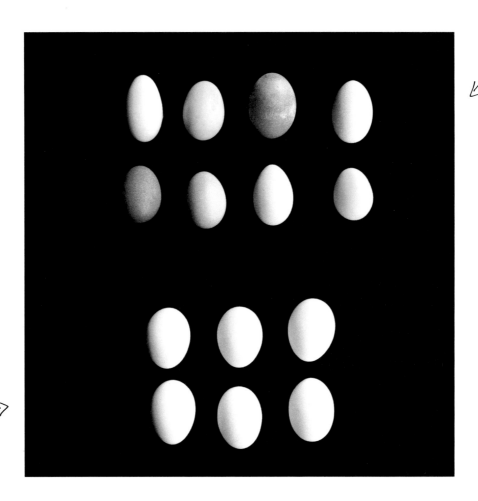

… compared to industrially farmed eggs we find in supermarkets.

Ten more fascinating facts about chickens

- Chickens descended from dinosaurs.
- Chickens outnumber humans by almost three to one. Every year, approximately nineteen billion chickens are reared worldwide.
- Chickens of some breeds can lay up to 260 eggs per year.
- A chicken can live up to ten years.
- Hens prefer to mate with dominant males and can eject the sperm of subordinate males from their bodies.
- Chicks like to peck and do so even when they are not eating their food, just like our babies like to suckle on pacifiers.
- Whether a piece of meat is dark or light is related to how frequently the chicken flexed its muscles. Because chickens walk more than fly, the leg is darker than the breast meat.
- It is not unusual for more than one chicken to lay eggs in the same nest. Sometimes, fake eggs are used to encourage chickens to lay eggs where farmers want them—that is, in their coops. My free-range chickens often lay eggs under bushes and I have to go on a treasure hunt to find them.
- The normal body temperature of a chicken is much higher than ours: 107°F (or 41°C).
- Chickens have no teeth but still have to break down their food to digest it. They do so by ingesting little stones and crunching their food with a special part of the stomach that is lined with very strong muscles called the gizzard.

Isabella
pondering about
evolution

Definitions

A heritage chicken must adhere to all of the following:

APA Standard Breed

Heritage chickens must be from parent and grandparent stock of breeds recognized by the American Poultry Association (APA) prior to the mid-twentieth century; whose genetic line can be traced back multiple generations; and with traits that meet the APA Standard of Perfection guidelines for the breed. Heritage chickens must be produced and sired by an APA Standard breed. Heritage eggs must be laid by an APA Standard breed.

Naturally mating

Heritage chickens must be reproduced and genetically maintained through natural mating. Chickens marketed as heritage must be the result of naturally mating pairs of both grandparent and parent stock.

Long, productive outdoor lifespan

Heritage chickens must have the genetic ability to live a long, vigorous life and thrive in the rigors of pasture-based, outdoor production systems. Breeding hens should be productive for five to seven years and roosters for three to five years.

Slow growth rate

Heritage chickens must have a moderate to slow rate of growth, reaching appropriate market weight for the breed in no less than sixteen weeks. This gives the chicken time to develop strong skeletal structure and healthy organs prior to building muscle mass.

References

Abeyesinghe, S.M. 2005. "Can Domestic Fowl, *Gallus gallus domesticus*, Show Self-Control?" *Animal Behaviour* 70 (1): 1–11.

Barber, Joseph, Janet Daly, Catrin Rutland, and Andy Cawthray. 2012. *The Chicken: A Natural History*. New York: Race Point Publishing.

Clutton-Brock, Juliet. 1981. *Domesticated Animals from Early Times*. London: British Museum (National History)

Darwin, C. R. 1859. *On the origin of species by means of natural selection, or the preservation of favoured races in the struggle for life*. London: John Murray.

Stamp Dawkins, Marian. 1995. "How Hens View Other Hens. The Use of Lateral and Binocular Visual Fields in Social Recognition." *Animal Behaviour* 132 (7/8): 591–660.

Bekoff, Marc, Colin Allen, and Gordon M. Burghardt, eds. 2002. *The Cognitive Animal: Empirical and Theoretical Perspectives on Animal Cognition*. Cambridge: MIT Press.

Griffin, Donald R. 2001. *Animal Minds: Beyond Cognition to Consciousness*. Chicago: The University of Chicago Press.

Grandin, Temple, and Mark Deesing, eds. 2004. *Genetics and the Behavior of Domestic Animals*, 2nd ed. Boston / New York / San Diego: Academic Press. Please confirm publication location. Online, it looks like it's London, Waltham, and San Diego.

Grandin, Temple, and Mark Deesing. "Distress in Animals: Is it Fear, Pain or Physical Stress?" Paper presented at the American Board of Veterinary Practitioners – Symposium 2002, Manhattan Beach, California, May 2002. Please confirm.

Hauber, Mark E. 2014. *The Book of Eggs: A Life-Size Guide to the Eggs of Six Hundred of the World's Bird Species*. Edited by John Bates, and Barbara Becker. Chicago: The University of Chicago Press.

Lori Marino. 2017. "Thinking chickens: a review of cognition, emotion,

and behavior in the domestic chicken." *Animal Cognition* 20 (2): 127–147.

Potts, Annie. 2012. *Chicken (Animal)*. London: Reaktion Books. Please confirm. Title seemed to be incorrect in PDF.

Rugani, Rosa, Giorgio Vallortigara, Konstantinos Priftis, and Lucia Regolin. 2015. "Number-space mapping in the newborn chick resembles humans' mental number line." *Science* 347 (6221): 534–536.

Zeuner, Frederick E. 1963. *A History of Domesticated Animals*. New York: Harper & Row. Confirm publication location.

Chickens (January 2016) Needs more info. Article name, author, page numbers.

Chicken Breeds, Volume 11F Needs more info. Article name, author, page numbers.

"The Complete Chicken Guide," *Modern Farmer*, Spring 2016, 54–65. Is "The Complete Chicken Guide" the name of the issue? What's the title of the specific article used? And author of that article?

Carol Davis, "Saving Rare Breeds," *Out Here*, Spring 2016, 12–17. Should this be Out Here magazine? PDF had it listed as Out There.

the website of The Livestock Conservancy; "Conservation Priority List"

Magazines
Chickens (January 2016)
Chicken Breeds, Volume 11F
Modern Farmer: "The Complete Chicken Guide," Issue 11 (spring 2016), pp. 54–65
Out There (spring 2016): Carol Davis, "Saving Rare Breeds", S. 12–17

Internet
https://livestockconservancy.org/index.php/heritage/internal/heritage-chicken

Special thanks

*to Hunter College Animal Behavior &
Conservation Program and especially to my
professors Diana Reiss, Mark Hauber,
Sheila Chase, Joseph Barber, and
Ofer Tchernichovski.*

First published in Germany by Schirmer/Mosel as
Meine Hühner und ich in 2017.

Library of Congress Control Number: 2017949404

ISBN: 978-1-4197-2991-1

Authorized English language edition of
My Chickens and I for distribution in the United
States of America and Canada. Originated by
Schirmer/Mosel Munich in 2017.

Text and drawings © 2017 Isabella Rossellini
Photographs © 2017 Patrice Casanova
© 2017 by Schirmer/Mosel Verlag GmbH, Munich.
All rights reserved.
A Schirmer/Mosel Production.
www.schirmer-mosel.com

Cover design © 2018 Abrams

Printed and bound in Italy
by EBS, Verona
10 9 8 7 6 5 4 3 2 1

Abrams Image books are available at special
discounts when purchased in quantity for
premiums and promotions as well as fundraising or
educational use. Special editions can also be created
to specification. For details, contact
specialsales@abramsbooks.com or the
address below.

ABRAMS The Art of Books
195 Broadway, New York, NY 10007
abramsbooks.com

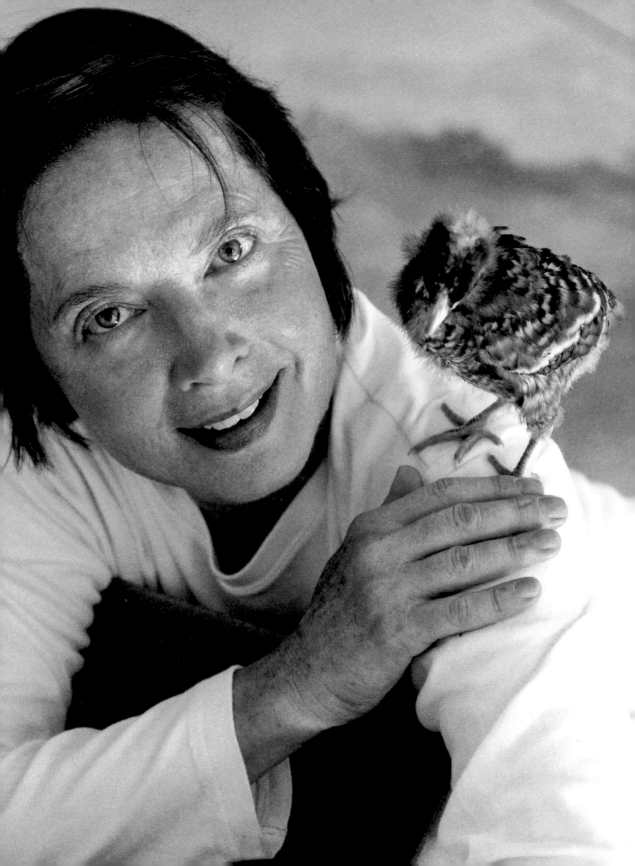

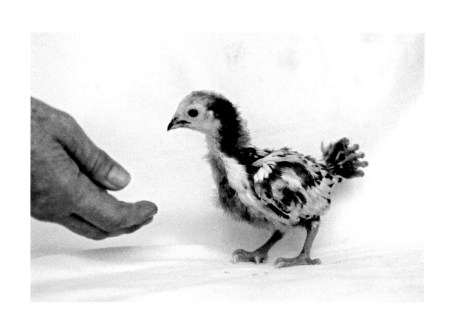

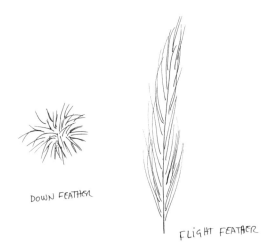

DOWN FEATHER

FLIGHT FEATHER

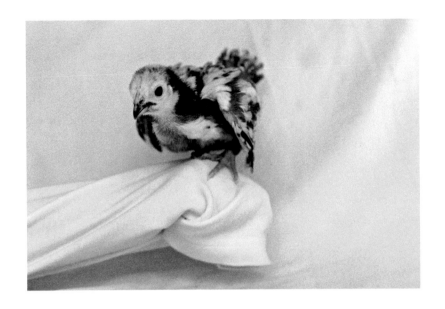

Baby chicks are born with only down feathers—
the ones we line our winter coats with—and
grow flight feathers as they get older.

Once they grow flight feathers on their tails
and wings, they start attempting …

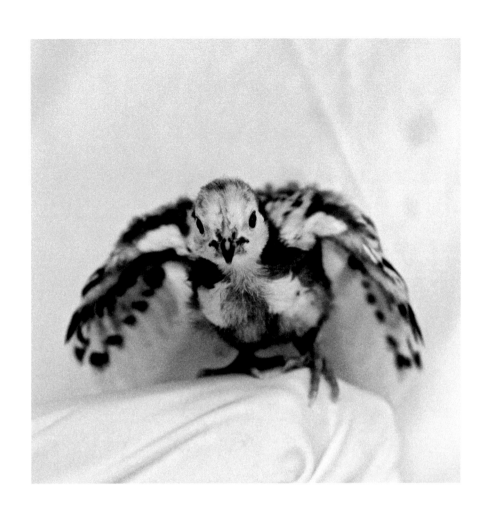

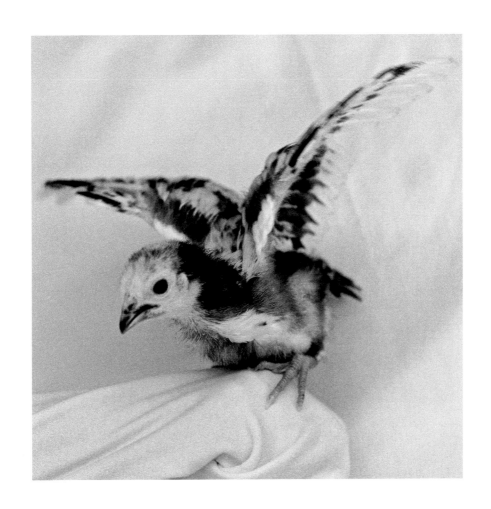

… to fly!

Once my chickens learned how to fly,
they didn't stay on the set, which I had baited with worms,
but flew right into the bag containing the worms.
Chickens are smart!

I started to research and read about them.

And I found out …

… that their brains are small,
but they are NOT stupid!

They recognize up to one hundred individuals in their coop,
and even recognize different people.

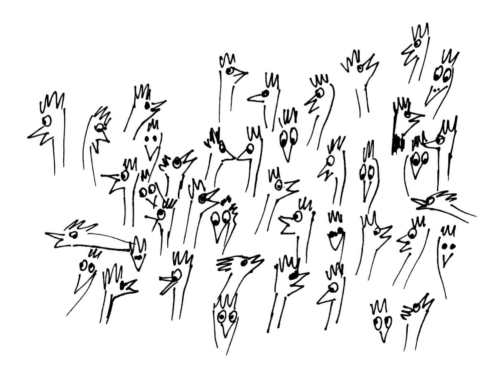

They can estimate quantities.
They cannot count like we do

1, 2, 3, 4, 5, etc.

but know that two is less than five,
four is more than one, and
three is more than two.

In scientific experiments,
chickens have demonstrated
that they have self-restraint and
the ability to plan for the future.

They were taught to peck at a button
to get a pellet of food.

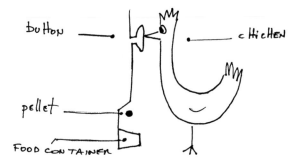

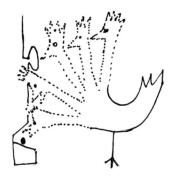

If they pecked fast,
they obtained one pellet of food,
but if they pecked slowly,
they obtained a lot of pellets.

Ninety percent of
the chickens showed
self-restraint, and learned
how to peck slowly so
they could eat more.

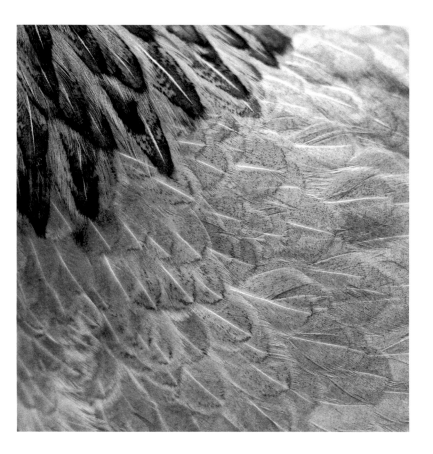

Chickens see more colors than we do.
We have three color receptors; they have four.
Everything they look at appears differently to them.
Their wonderful plumage must look
much more colorful to them.

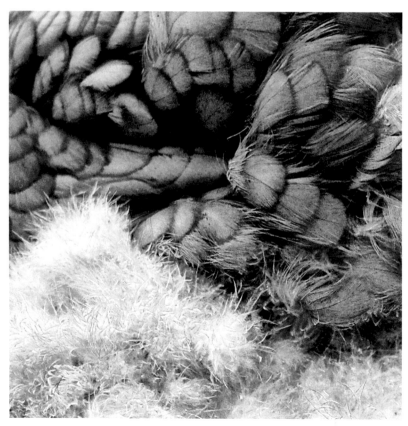

Chickens cannot move their eyes
from side to side or up and down as we do.

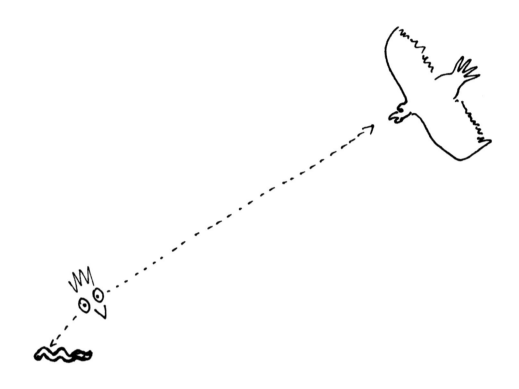

Instead, they can focus one eye on a nearby object,
like a worm crawling on the ground,
and the other eye can focus on the sky
and scan for predators like hawks.

They have a special call to say
"danger from above!"
when a hawk approaches …

... and another call for
"danger from below!"
when a cat or other earthbound
predator approaches.

Chickens emit dozens and dozens of calls
to express pleasure, displeasure, fear, hostility, surprise,
anger, seduction, and greetings ...

… which, combined with postures, attitude, and body language, give them a rich ability to communicate.

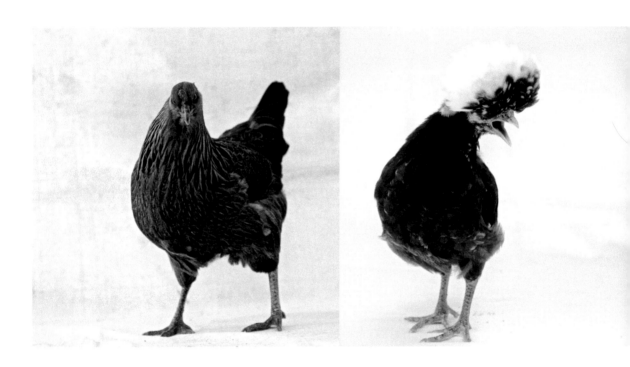

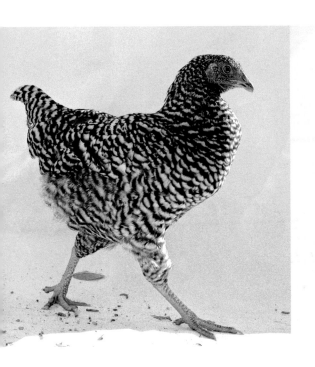

They move quite quickly,
but Patrice's photos captured their varied expressions.
They remind me of silent movie stars!

The ancestor
(that is, the great, great, great,
great, great, great, great, great, great,
great, great, great, great, great, great, great,
great, great grandparents) of Asia's
Red Junglefowl …

… evolved to become
our domestic chicken.

All domestic animals, in fact,
have wild ancestors.

The great, great, great, great, great,
great, great, great, great, great, great, great,
great, great, great, great grandparents
of the wild boar …

… evolved to become
our domestic pig.

The great, great, great, great, great,
great, great, great, great, great, great, great,
great, great, great, great grandparents
of the aurochs cow …

… evolved to become
our domestic cow.

Our ancestors
(our great, great, great, great, great,
great grandparents) captured wild animals
and started to select the ones they liked the most:
the ones that were calmer, easier to handle,
and FATTER—because they ate them!

In other words, they used the laws of evolution
to create new kinds of animals that would be useful to them.

Not all animals could be domesticated.
The great, great, great, great, great, great,
great, great, great grandparents of the

giraffe

rhino

zebra

leopard

could NOT be domesticated.

Wild animals that could be domesticated
had to have certain characteristics.

They had to naturally live
in large groups.

They had to have parent-baby bonds
that could be skewed to make
them bond with us, too.

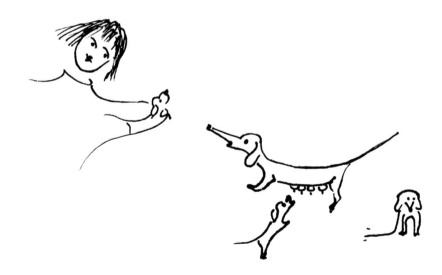

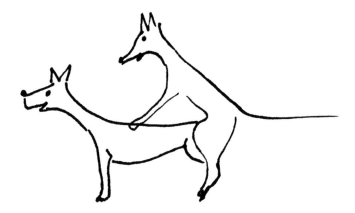

They could NOT be choosy.
We humans—the domesticators—chose their mates
to select certain traits.

Our ancestors did not know about the science of evolution,
but they knew that babies resembled their parents.
If they mated a male wolf that was not aggressive
with a female wolf that was not aggressive …

... chances were that most of their puppies
would also not be aggressive.

Generation after generation of breeding
for thousands and thousands of years …

and the wolf (man-eater)

became the dog
(man's best friend).

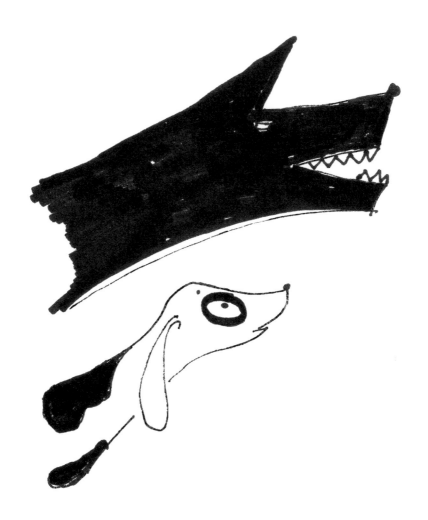

*"If man goes on selecting, and thus argumenting,
any peculiarity, he will almost certainly
modify unintentionally other parts of the structure
owing to the mysterious laws of correlation."*

—Charles Darwin's *On the Origin of Species*, 1859

By reducing the wolf's aggression and increasing its friendliness, men unintentionally selected other characteristics:

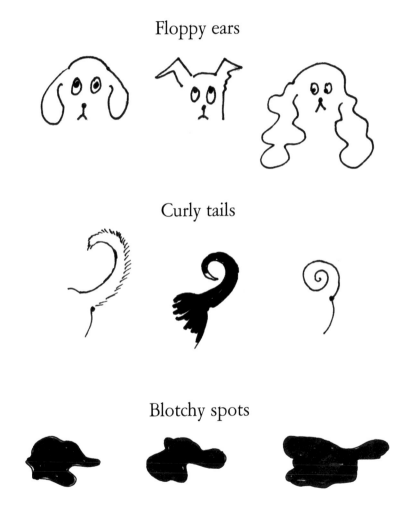

Floppy ears

Curly tails

Blotchy spots

Blotchy spots are the unmistakable mark of domestication:
Every domesticated animal has them, from cows to cats to goats
to my dog Pinocchio.

The first animal to be domesticated was the dog
fifteen thousand years ago.

Other instances of domestication, including chickens, began
eight thousand to ten thousand years ago with the advent of agriculture.

Yes, we domesticated plants, too!
Making them bigger and sweeter—because we eat them.

Not only did we create domestic animals,
but we even went one step further and created BREEDS.
We selected them for talents:

Hunting dogs

Herding dogs

Guard dogs, GRRR!

"Nature gives successive variations;
man adds them up in certain directions useful to him.
In this sense he may be said to have made for himself
useful breeds."

—Charles Darwin's *On the Origin of Species*, 1859

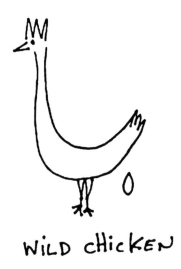

WILD CHICKEN

Chickens were selected to be fatter and fatter
and to lay more and more eggs.

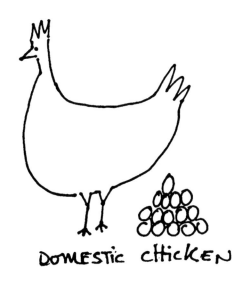

DOMESTIC CHICKEN

Farmers noticed that certain breeds were superior layers
while others were better for meat, which resulted in today's separation
of egg and meat farming.

Chickens that are commonly found in supermarkets
are killed at six or seven weeks old. These chickens are called
broilers and through selective breeding they grow
fatter and more quickly than any heritage breeds.
Broilers have a huge appetite.

Broiler chicken
at 4 weeks old

Heritage chicken
at 4 weeks old

Male

When I bought my chicks I ordered only females,
but a few chicks turned out to be roosters.

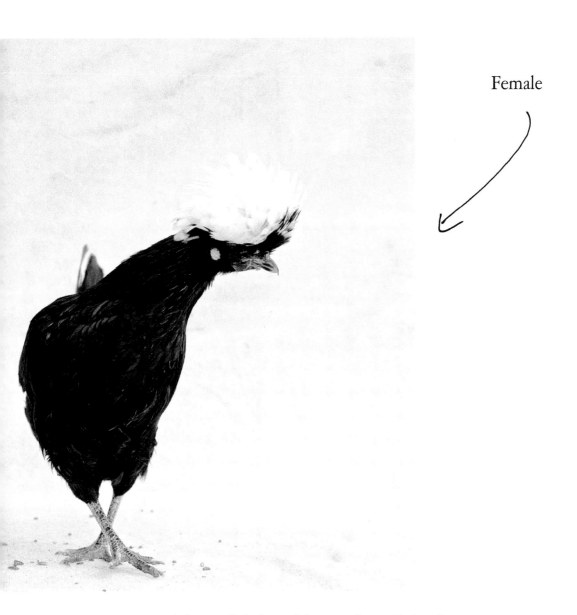

Female

The Polish breed is not from Poland,
but rather derives its name from the resemblance to
crested feathered caps worn by Polish soldiers.

When males and females of the same species
look different it is called "sexual dimorphism." It is a result of
different evolutionary histories. Male chickens fight a lot while
females don't, even though there is a definite hierarchy
among the females, too, called "pecking order."

The accumulation over centuries of the bigger and
stronger roosters winning fights, mating with females, and
having baby chicks resulted in their bodies being bigger
and stronger than the hens.

My young roosters are already more colorful than my hens.
It could be that the females' mating preferences encouraged the males
to evolve to be more visually attractive. Dominant roosters
crow more frequently than submissive ones.
Each has a distinct voice.

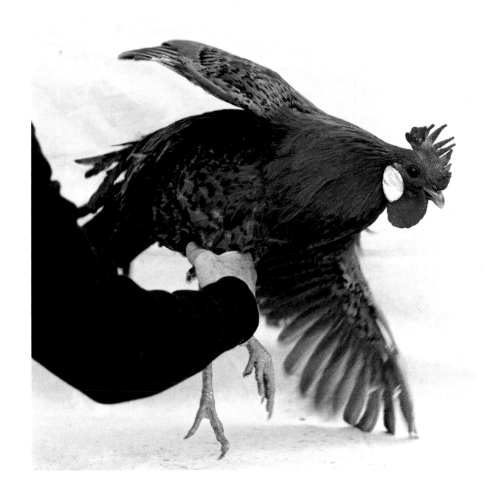

Chickens do not need a rooster to lay eggs.
They need the rooster to fertilize the eggs and have chicks.

In the spring, chickens lay an egg almost every day.
In the fall, when the days become shorter, they lay very few eggs.

In order for the chickens to lay eggs in the winter
they have to be kept under a light.

Chickens have been selected against broodiness.
Modern chickens in industrial farms do not know
how to be good mamas anymore.

Broodiness is when chickens stop laying eggs and sit on the ones
that are placed in the nest. Mama chicken hardly eats or drinks.
She just keeps the eggs warm at a temperature between 99° and 102°F
(37° and 39°C) to allow for the development of the chicks,
which hatch twenty-one days later.

A few days before hatching,
the chicks start vocalizing from inside the eggs,
and mama replies with clucking noises.

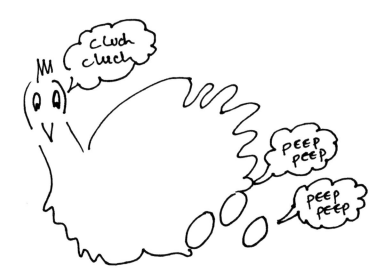

The chicks' chirping might be the mechanism
that allows the synchronization of their hatching.
They all come out of the eggs within a few hours of each other,
although each egg might have been fertilized days apart.

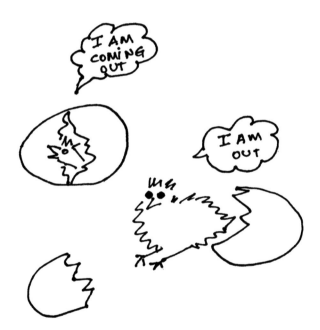

For the first day or two after hatching, the chicks don't eat.
The yolk inside each egg has provided them with enough nourishment
for a couple of days. This is when my chicks were placed in the box
and mailed to me by air!

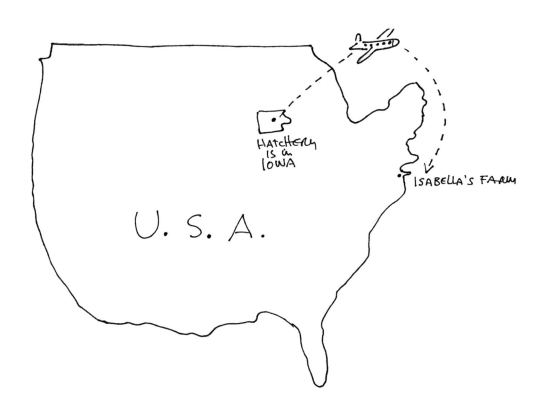

This is also a delicate period when chicks imprint.
Imprinting is the rapid and complex learning period when
chicks discover that they are chickens, the same species as their mothers.
But if they are exposed to other moving creatures during this time,
the chicks might imprint on them instead.
Imprinting could be skewed!

At my farm, I have different breeds of chickens, including the heritage breeds, some of which are endangered.

Industrial farming raises billions of chickens every year, but many old breeds are left behind in favor of ones that can lay more eggs or grow fatter and more quickly.

There are billions of chickens but no diversity.

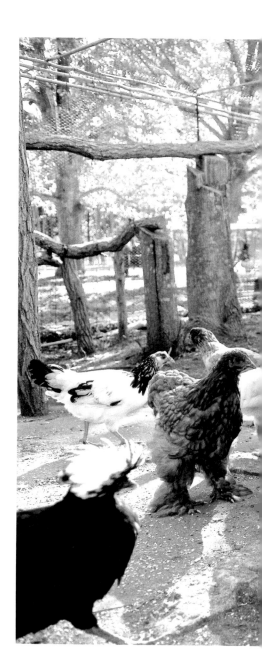

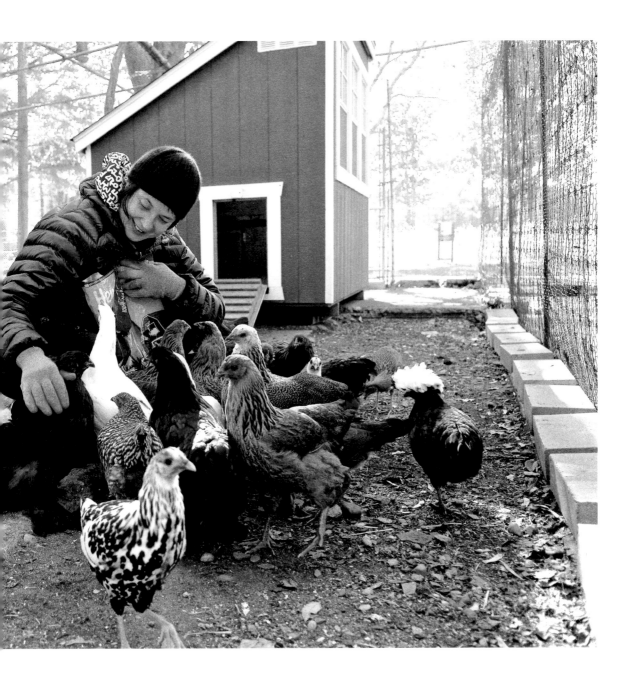

Imagine if what happened to chickens in industrial farming happened to dogs. We would lose all breeds in favor of only one or two.

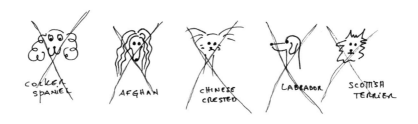

That's right: no more cocker spaniels, Afghan hounds, Chinese crested, Labradors, or Scottish terriers.

There would only be the fattest poodles and the longest dachshunds because, if we treated them like chickens, we would eat them!

Diversity is important!

It is the raw material with which evolution works.
Heritage breeds are defined as chickens that still know how
to reproduce naturally and be mamas.
They can survive outdoors by eating in pastures,
and grow slowly, to reach adult size in at least four months,
giving them time to develop strong skeletons.
These types of traits are good and should be preserved …
they may come in handy in the future!
Small farms like mine can help maintain chicken diversity
by raising many breeds, especially heritage breeds.

Perfection doesn't exist:
The secret in nature lies in diversity.

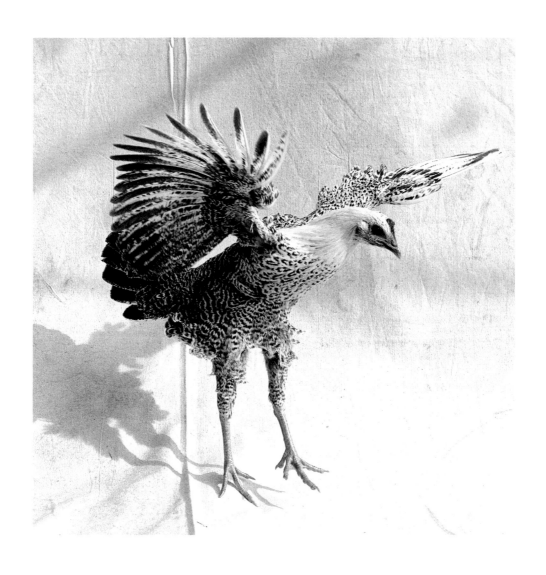

The Fayoumi lived in Egypt three thousand years ago,
when they were probably eaten by the pharaohs.

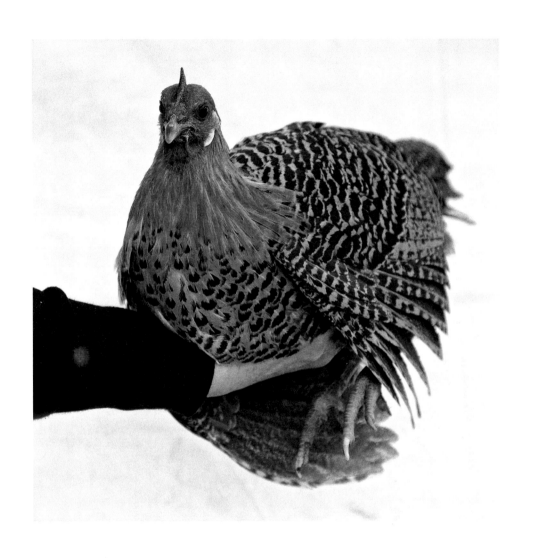

The Campine are originally from Belgium.
Julius Caesar is said to have taken these breeds of chickens
back to Rome after he had completed a spell of looting in Belgium.

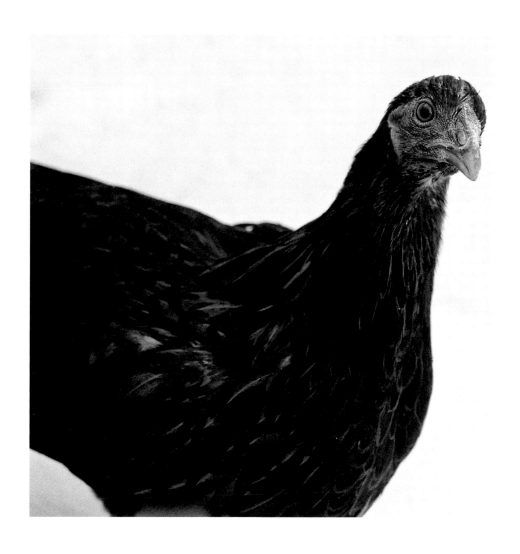

The Redcap fell out of favor and became nearly extinct
in their native England by 1900. They lay white eggs even if their earlobes
are red. This is unique because most breeds that lay white eggs
have white earlobes.

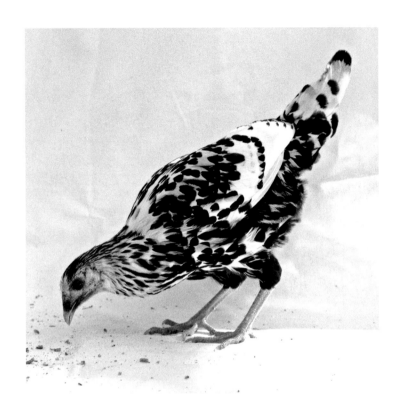

Hamburg chickens, despite their name, are believed
to have originated in Holland in the fourteenth century.
I am enchanted by their unusual green ears.

GREEN
EAR

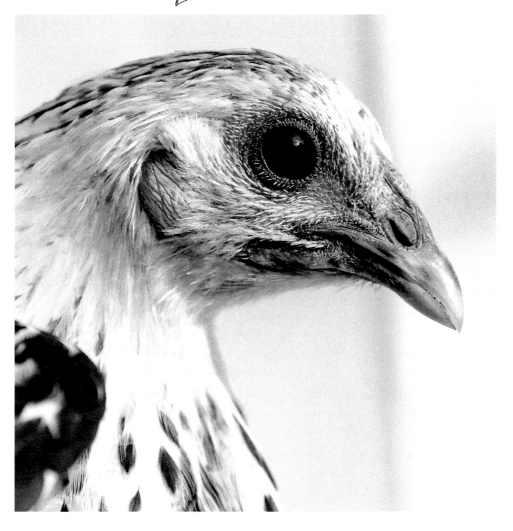

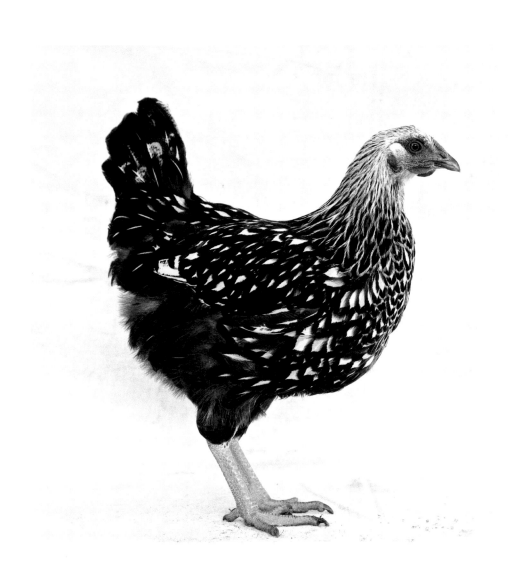

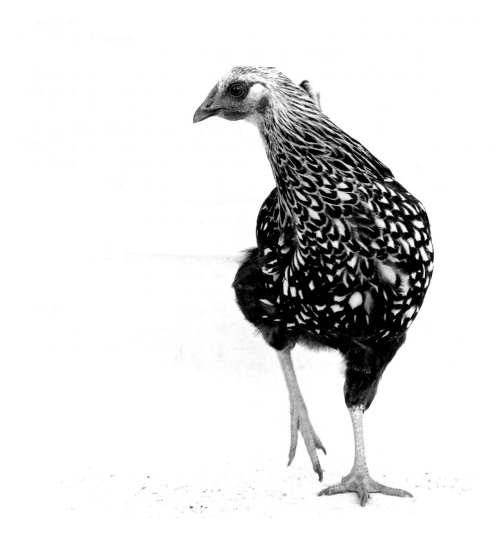

This breed is called "Wyandotte" after the Native American tribe
Wyandot, although it was the Spaniards who are believed
to have brought the chickens to North America, while …

… the Araucana are from Chile,
and DNA analysis suggests that these birds
were in South America before the arrival of Europeans.
If correct, it would mean that Polynesian explorers
arrived in the Americas before Columbus.

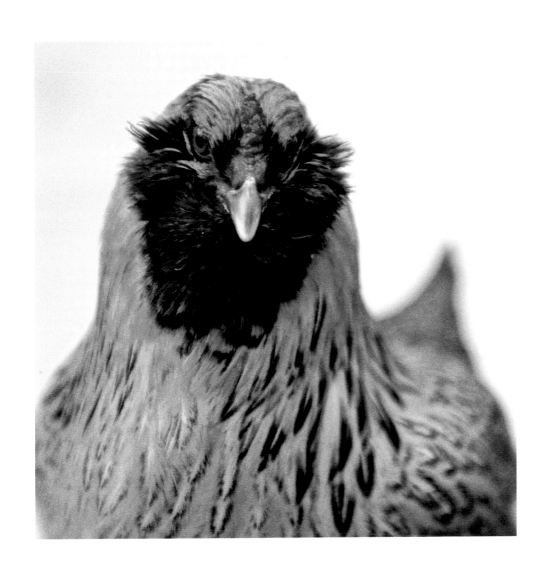

They lay blue eggs.

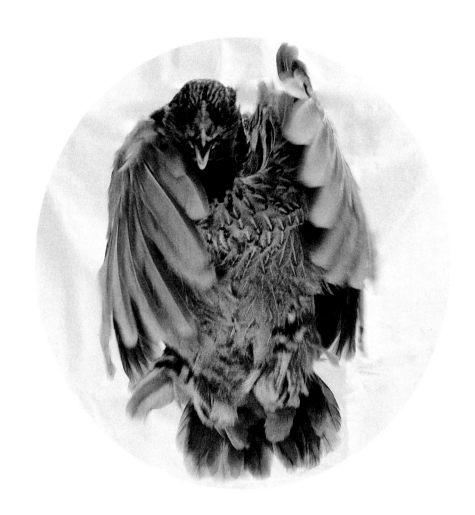

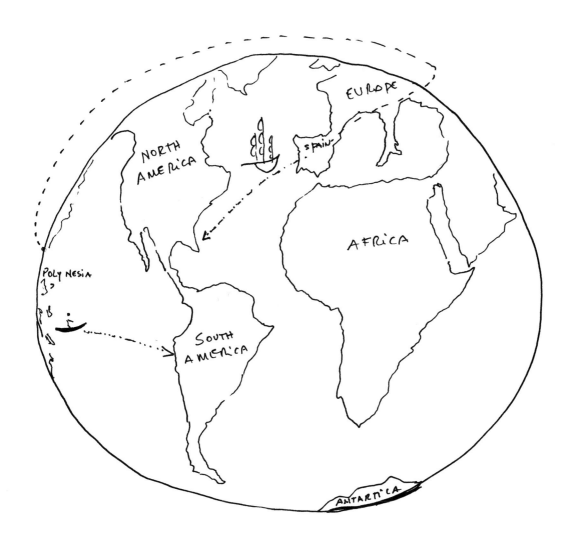

The Brahma were first exported to England in December 1852,
when George Burnham sent nine of them from Bengal
to Queen Victoria as a gift.

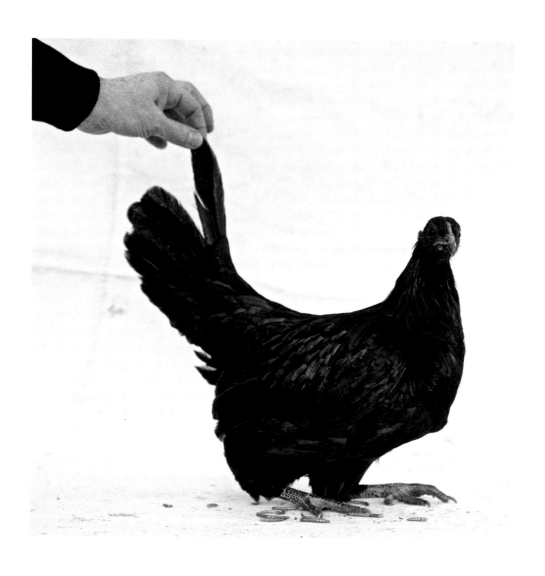

The Sumatra are from the isles of Sumatra in Indonesia.
They are a very old breed that still retains the ability to fly.
I often find mine sitting in trees.

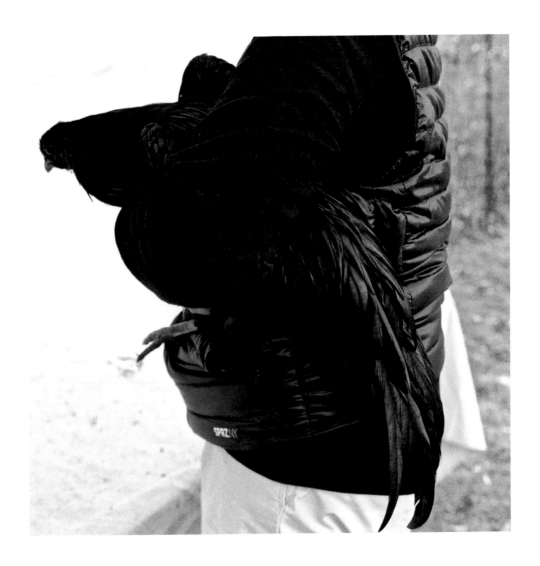

The rooster has the longest tail, trailing behind him.

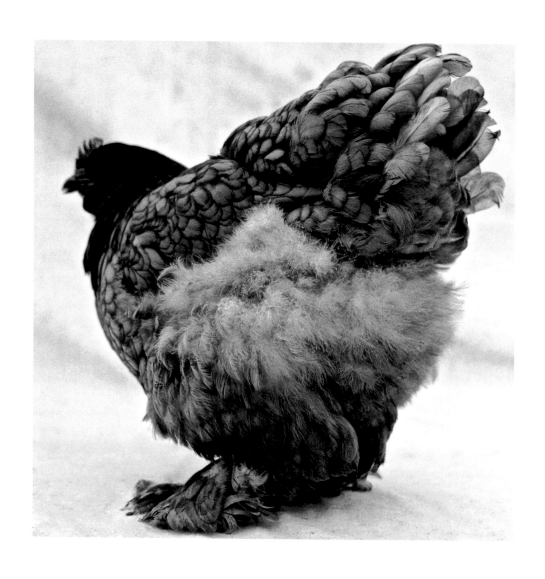

The Cochin are originally from China.
They are the largest breed and also the softest.
This one reminds me …

... of Christian Dior's "New Look."

Five months
after the chicks
arrived at my farm,
I found the first eggs
in their coop.

They had reached
adulthood.

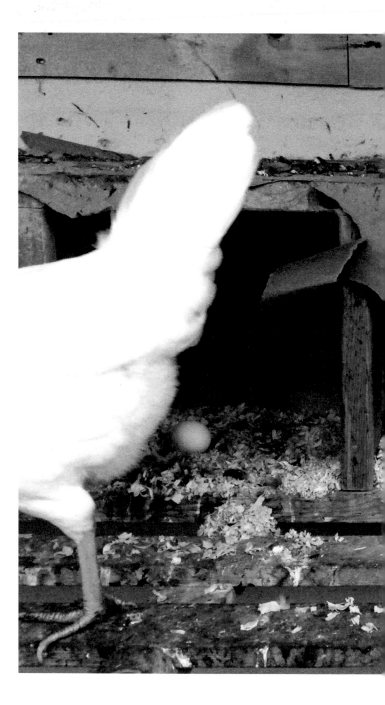